A TRACTATE ON JAPANESE AESTHETICS

A TRACTATE ON JAPANESE AESTHETICS

DONALD RICHIE

Stone Bridge Press • *Berkeley, California*

Published by
Stone Bridge Press
P.O. Box 8208
Berkeley, CA 94707
TEL 510-524-8732
sbp@stonebridge.com
www.stonebridge.com

Manufactured in the United States of America.

LIBRARY OF CONGRESS CATALOGING-IN-PUBLICATION DATA
Richie, Donald, 1924–
 A tractate on Japanese aesthetics / Donald Richie.
 p. cm.
 Includes bibliographical references.
 ISBN 978-1-933330-23-5 (pbk.)
 1. Aesthetics—Japan. I. Title.

BH221.J3R53 2007
111'.850952—dc22

 2007017228

for

J. Thomas Rimer

"Art is the imposing of a pattern on experience and our aesthetic enjoyment is recognition of the pattern."

ALFRED NORTH WHITEHEAD
Dialogues (1954)
10 June 1943

CONTENTS

PREFACE

IN WRITING ABOUT traditional Asian aesthetics, the conventions of a Western discourse—order, logical progression, symmetry—impose upon the subject an aspect that does not belong to it. Among other ideas, Eastern aesthetics suggests that ordered structure contrives, that logical exposition falsifies, and that linear, consecutive argument eventually limits.

As the aesthetician Itoh Teiji has stated regarding the difficulties that Japanese experience in defining aesthetics: "The dilemma we face is that our grasp is intuitive and perceptual rather than rational and logical." Aesthetic enjoyment recognizes artistic patterns, but such patterns cannot be too rigid or too circumscribed.

Most likely to succeed in defining Japanese aesthetics is a net of associations composed of listings or jottings, connected intuitively, that fills in a background and renders the subject visible. Hence the

Japanese uses for juxtaposition, for assembling, for bricolage.

In any event, for any consideration of aesthetics, East or West, the quality of apprehension is sensibility—an awareness, a consciousness, a sensitivity. It is alive and often unfriendly to interpretation, and if it is to be pinned to the page, then feints and indirections are some of the means.

We thus should not strive for logical conclusions. Rather, we ought to define those perceptions and variances of aesthetic appreciation through a style that conveys something of the very uncertainty of their description.

Many Japanese writers prize a quality of indecision in the structure of their work. And something too logical, too symmetrical is successfully avoided when writers ignore the suppositions of the questions asked of them. It is then not the assumptions of the writer's controlling mind that are followed but, as the Japanese phrase it, the brush itself.

Zuihitsu, the Japanese word we might translate as "essay," implies just that—following the brush, allowing it to lead. The structure is the multiplicity of strokes that make up the aesthetic quality, one which they imply and which we infer.

In this book I have sought to approximate this

neglect of logical method, this dismissal of linear structure, and both in the text and in its placement on the page I have attempted to give some idea of the progression of a *zuihitsu*.

DONALD RICHIE
Tokyo, 2007

AESTHETICS IS THAT branch of philosophy defining beauty and the beautiful, how it can be recognized, ascertained, judged.

In the West the term was first used in 1750 to describe a science of sensuous knowledge. Its goal was beauty, in contrast with logic, whose goal was truth. Based upon dichotomies (beauty/truth, aesthetics/logic) the definition was elaborated into a multi-faceted concept assuming that opposites and alternates lead to an aesthetic result. The conjectures and conclusions were those of eighteenth-century Europe but are still common today.

There are, however, different criteria at different times in different cultures. Many in Asia, for example, do not subscribe to general dichotomies in expressing thought. Japan makes much less of the body/mind, self/group formation, with often marked consequences. Here we would notice that what we would call Japanese aesthetics (in contrast to Western aesthetics) is more concerned with process than with product, with the actual construction of a self than with self-expression.

The Western concept finds beauty in something we admire for itself rather than for its uses, something that the philosopher Immanuel Kant (1724–1804) called "purposiveness without a purpose."

Traditional Japan emphasizes differently. It is closer to such pre-Enlightenment European definitions as Chaucer's "Beautee apertenant to Grace," where the grace of fitness excites intellectual or moral pleasure and gives rise to the concept of social approval in the form of good taste.

Jean de la Bruyère, the French moralist, early in the seventeenth century defined the quality: "*Entre le bon sens and le bon goût il y a la différence de la cause et son effet.*" Between good sense and good taste there is the same difference as between cause and effect, an observation with which Chaucer, as well as the aesthetically traditional Japanese, might have agreed. In matters aesthetic, taste remains an observation of deserved worth, and that should take care of that—except that we are not all agreed as to what good sense consists of.

Some countries say one thing, some say another. The Japanese traditionally maintain that we have been given a standard to use. It is there, handy, daily: things as they are, or Nature itself. This makes good sense, the only sense, really—Nature should be our model, we are to regard it, to learn from it. When Keats upset aesthetic patterning in the West with his notorious assertion that "truth is beauty; beauty, truth," he was very close to the Asian notion that these are identical

"The flowing river never stops and yet the
water never stays the same.
Foam floats upon the pools, scattering,
re-forming, never lingering long.
So it is with man and all his dwelling plac-
es here on earth. . . .
The place itself does not change, nor do
the crowds.

. . .

Even so, of all the many people I once
knew only one or two remain.
They are born into dusk and die as the
day dawns, like that foam upon the water.
People die and are born—whence they
come and where they go, I do not know.

. . .

A house and its master are like the dew
that gathers on the morning glory.
Which will be the first to pass?"

KAMO-NO-CHŌMEI (1153–1216)
from *Hōjōki* (An Account of My Hut),
translated by Yasuhiko Moriguchi
and David Jenkins

Among the qualities that can be derived from the assumptions of traditional Japanese aesthetics Donald Keene has distinguished suggestion, irregularity, simplicity, and perishability. These might indeed be seen as basic ingredients in traditional Japanese taste but, at the same time, Keene notes that "exaggeration, uniformity, profusion, and durability are by no means absent."

Western aesthetics is sometimes familiar with simplicity, asymmetry, and suggestion, but the idea that beauty lies in its own vanishing is an idea much less common. Perishability remains, however, what Keene has called "the most distinctively Japanese aesthetic ideal." It is certainly among the earliest, being based on the Buddhist concept of *mujō*, a term usually translated as "impermanence": nothing is stable, and our only refuge lies in accepting, even celebrating this.

and to the suggestion that dichotomies are tools too dull to delineate the wholeness of observation.

Bruyère's *aperçu* is, indeed, so sensible that one would expect it to apply just everywhere. It does not, but it does to Japan. As the aesthetician Ueda Makoto has said: "In premodern Japanese aesthetics, the distance between art and nature was considerably shorter than in its Western counterparts." And the novelist Tanizaki Jun'ichirō has written in that important aesthetic text *In Praise of Shadows*: "The quality that we call beauty . . . must always grow from the realities of life."

Elsewhere—in Europe, even sometimes in China—Nature as guide was there but its role was restricted to mimesis, realistic reproduction. In Japan this was traditionally not enough. It was as though there was an agreement that the nature of Nature could not be presented through literal description. It could only be suggested, and the more subtle the suggestion (think *haiku*) the more tasteful the work of art.

Here Japanese arts and crafts (a division that the premodern Japanese did not themselves observe) imitated the means of nature rather than its results. One of these means was simplicity. There is nothing merely ornate about nature: every branch, twig, or leaf counts. Showing structure, emphasizing texture—even boldly displaying an almost ostentatious lack of artifice—this was what the Japanese learned to do. Such simplicity was to be delineated by a number of categories—for example, *wabi* and *sabi*, those conjoined twins of Japanese aesthetics that we will later visit. One result was that, as a prerequisite for taste, this simplicity was found beautiful.

IN THE WEST, the word "aesthetic" has many uses. The most widely applied distinguishes the beautiful from the merely pleasing, or the merely moral or (in

particular) the merely useful. In its assumptions of a sensuous knowledge the goal of which is beauty (in contrast with logic always in search of truth), it further elaborates into a doctrine insisting that, whatever the principles of beauty are, they are basic since all other principles (the good, the right) are derived from them.

The above assumption is thought truthful because it is presumed that actual knowledge comes from an immediate presentation of reality rather than from analytical thought itself—"aesthetic" derives from the Greek *aesthesis,* which means perception/sensation. From such assumptions grew that branch of philosophy called Aesthetics—dealing with the beautiful, with theories of beauty, with its essential character, with the emotions stimulated by the beautiful, and with that general agreement manifested in "taste."

In the East, however, there was no word corresponding to "aesthetic." Japan coined its presumed equivalent (*bigaku*) only in 1883, and this was because a term became necessary in order to refer to what foreigners meant when they spoke of *ästhetik,* the German philosopher Hegel's term for the "science of the fine arts."

Once the word was in place, however, the Uni-

versity of Tokyo could then offer (1886) a course in Aesthetics. These classes were naturally devoted to Western (particularly German) ideas and little attention was paid to the native tradition even though a considerable amount of traditional writing on the nature of art already existed.

One reason for this was that there was no rubric under which these "premodern" aesthetic ideas could be subsumed. If there is no term for something,

it might be thought that the commodity is of small importance. But it is just as likely that this something is of such importance that it is taken for granted, and thus any conveniences, like words, for discussing it are unnecessary.

(This was back then, not now. Foreigners now seeking a traditional aesthetic climate in Japan are disappointed. Though there are attempts to bridge the gulf—Pokémon is really just like Hokusai, etc.—the erosion of the traditional is enormous. On the other hand, Japan's traditional culture is centuries deep and prior patterns can still be found. These occur in the many cultural fossilizations (modern tea ceremony, the Kabuki, and so on) and also in those formations not much noticed: the structure of the language, the nature of religion in the country.)

Traditional Japanese aesthetics still lacks a definition. There were and are, however, plenty of terms in Japanese (*wabi, sabi, aware,* and more, most of which we will become acquainted with in later pages), but these all refer to qualities, to parts of an assumed but unnamed whole. Indeed, elements of aesthetic import and matters of taste were once so common in traditional Japanese life that any central assumption must indeed have seemed unnecessary.

Michael Dunn distinguishes five "tastes" that inform the Japanese aesthetic. These are *kodai*, which signifies antiquity; *soboku*, which has been translated as "artless simplicity"; *wabi* and *iki* (elsewhere defined in this text); and *karei*, "gorgeous splendor," i.e., daimyo (warlord) taste.

A parallel to such rarefaction of Japanese aesthetic terms may be seen in the elaborations of taste in its more elemental aspect—that involving the human tongue.

In addition to those enumerated in the West (sour, sweet, etc.), the Japanese distinguish a number of tastes they believe to be uniquely sensible to themselves. These include *awai* (delicacy), *umami* (deliciousness), and *shibui* (astringency). There are also examples of what the West would consider neologisms. *Nigai* is used for "bitter" and *egui* for "acridity." English does not differentiate between acridity and bitterness.

TANIZAKI JUN'ICHIRŌ'S REMARK that beauty rises from the realities of life forces us to wonder what these realities consist of. Certainly, as Ueda Makoto has phrased it, a distinctive feature of traditional aesthetic thought in Japan was a tendency to value symbolic representation over realistic delineation. Mimesis in its sense of an imitation of outward appearance was never an aim of traditional Japanese aesthetics. Rather, qualities existing under this outward surface were searched for and found. Beneath the glaze of a teacup were the qualities of *wabi* or *sabi*; in the sleeve of the kimono was discovered *fūryū* or *iki*.

The kind of aesthetic taste we are considering would not have been possible without an audience that had the means and time to create and enjoy it. Social scientist Thorstein Veblen (1857–1929) labled such a group the "leisure class" and maintained that it found its best development at the higher stages of "barbarian culture," such as "feudal Japan."

"In such communities," he continues, "the distinction between classes is very rigorously observed; and the feature of most striking economic significance in these class differences is the distinction maintained between the employments proper to the several classes."

A result was the creation of a leisured class—those powerful enough to live off others and strong enough to command the comforts of a concomitant luxury. As Veblen explains, "The consumption of luxuries, in the true sense, is a consumption directed to the comfort of the consumer himself, and is, therefore, a mark of the master."

Conspicuous connois-

Art was thus something to be experienced subjectively by the artist, not something to be regarded objectively. Similarly, appreciation emerged from the intimate depths of the artist (or his patron) and not from any scrutinizing at a distance.

Realism in the Western sense of the word played small part in the realities of life as experienced by the traditional Japanese artist. The expectations of the artist's cultivated sensibilities did not demand mimesis. Rather, indication, suggestion, simplicity took

seurship—the ability to distinguish between the noble and the ignoble in things consumable—thus becomes a means for the master, the wealthy owner, to pursue and achieve reputability.

Other contrivances for leisured power include, as Veblen explains, an eluding of any appearance of real utility or social use, as well as an avoidance of what is merely useful in contrast to what is essentially honorific. That this could also be construed as wasteful is, of course, one of the marks of the leisured class as a whole.

Taste is an indication of an aesthetically legitimate dominance. Hence its rules and regulations, its complications, and its numerous dicta to be observed. Canons of taste are indications of the approval or disapproval of things about which a favorable or unfavorable judgment of taste is to be passed.

In Japan as elsewhere, the longer this standard prevails, the more legitimate becomes the canon of taste itself. Precedence remains a powerful tool in assuring dominance.

the place of any fidelity to outward appearance. Both the aim and the result was an agreed-upon quality for which English has but one term: elegance.

Elegance—a sense of refinement, of beauty in movement, appearance, or manners; a tasteful opulence in form, decoration, or presentation; a restraint and grace of style. Most of the components of Japanese aesthetics carry this connotation of elegance.

This understanding of elegance also worked against any cultivation of realism. There is in tradi-

tional Japanese aesthetics no indication of art's ability to create beauty from ugly or otherwise inelegant materials. There is little indication of everyday occurrences in the lives of common people. Rather, what is more often stressed is the elegances familiar to the aristocracy, the wealthy.

The realities reflected in Japanese aesthetics and its products thus do not include the farmyard or the farmers themselves (except for special effects—of which more later). But they do include Nature. This reality-made Nature became the major subject of both Japanese art and aesthetics—though perhaps it might better be suggested as "Nature," since the Japanese version is so edited and abbreviated, so subjected to those very rules that eventually defined both the aesthetics and much of the art.

IF ELEGANCE IS to be chosen as a condition of excellence then there must be a general agreement as to what this elegance consists of. This is to be decided only through opinion. The qualities that make up the definition of the elegant are all socially derived.

So, if aesthetics in the West is mainly concerned with theories of art, that of Japan has always been concerned with theories of taste. What is beautiful depends not upon imagination (as Addison thought)

A Western justification of taste was voiced by the philosopher David Hume (1711–76), who held that this authorization of the beautiful was the result of experience and education. Men of taste were in a position to assess worth and beauty. They could set a universal standard. Hume's thesis inspired its direct contrast in Kant's view that the worth and beauty lay in the art work itself and not in any evaluation of it.

The Japanese definition of worth and beauty is much closer to Hume's than to Kant's. It is still believed that, although the elements found common to beauty are perhaps universal, it is their reception (the universal standard) that creates the excellence of the art.

nor qualities proper in the object (as Hume said) nor in its paradoxes (as Kant maintained) but rather in a social consensus.

The West is, of course, no stranger to the idea of taste mediating aesthetics. The Japanese standard of elegance as an agreed-upon and major component of beauty might be compared to that of French art during those years when were created the paintings, sculpture, architecture we now call rococo.

A "social" elegance was the major aesthetic criterion at Versailles. This included not only the sumptuousness, display, and luxury associated with the courts of Louis XIV and XV but also the simplicity that by contrast defined these qualities: the artlessness of demeanor that Saint-Simon admired, the rustic intentions of the various *fêtes champetres*, Marie Antoinette's Petit Hameau with its real cows, its real hay, and courtiers playing milkmaid and swain. All of this "simplicity" served to further define the general excess of rococo art.

One Japanese parallel is suggested in Katsura Rikyū, an imperial villa built in the early seventeenth century that copied earlier rural architectural styles (but used the finest of materials) and contrasted the elegance of the main building with its opulently rustic outhouses. Another parallel would be the ostentatious

Veblen in his account of the canons of Euro-American nineteenth-century taste turns his attention to this cultivation of the rural as a means of implying wealth by contrast. In a section on "Greenery and Pets" he describes an expensively maintained lawn, sprawling to a carefully wasteful extent, sometimes actually containing a cow, though one of a noticeably expensive breed. However, "the vulgar suggestion of thrift, which is nearly inseparable from the cow, is a standing objection to the decorative use of this animal." Consequently, "where the predilection for some grazing animals to fill out the suggestion of the pasture is too strong to be suppressed, the cow's place is often given to some more or less inadequate substitute, such as deer, antelope, or some such exotic beast. These substitutes. . . are in such cases preferred because of their superior expensiveness or futility, and their consequent repute."

What Veblen here describes could be equally applied to seventeenth-century leisured Japan with its similar search for a complicated simplicity—as in our example of the Katsura Rikyū Imperial Villa.

Sen no Rikyū, tea-master and arbiter of elegance, is usually credited with the further development of the Japanese aesthetic of simplicity.

It was Rikyū who reduced the size of the *chashitsu* teahouse, who introduced the rough black teabowls known as *raku* ware, who was the first to fashion flower holders from bamboo, and who reminded his disciples that "the tea ceremony is nothing more than boiling water, steeping tea, and drinking it."

The "tea ceremony" (*chanoyu*) became something of a focus for Japanese aesthetic concerns. It may have been nothing more than drinking tea, as Rikyū suggested, but its ramifications were complex. Its presumed simplicity was complicated by the various customs, rules, and regulations through which it was conducted, and it was the bureaucracy of the *chanoyu*

all-gold tea house of the warlord Toyotomi Hideyoshi (1536–98), with all of its gorgeous Momoyama-style paraphernalia, exhibiting true daimyo taste—as contrasted with the aesthetics ideal of the warlord's own tea-master, Sen no Rikyū (1522 –91), who was himself creating many of the subtle, understated, aesthetic standards we now associate with traditional Japanese art.

There is a further parallel between this attentive emulation of naturalness and the Japanese ordering of aesthetic tastes. Here we are not, any more than at Versailles, required to consider a real milkmaid pen-

that defined many aspects of Japanese aesthetics.

Rikyū's "return" to simplicity was also opposite the urge for ostentation that was the cultural imperative of his patron, the warlord hegemon Toyotomi Hideyoshi.

Yet, willing or not, Rikyū had to officiate at Hideyoshi's tea ceremony for the Emperor Ōgimachi (with its all-gold teahouse) and at the notorious *chanoyu* orgy (for thousands of guests) held by Hideyoshi at the Kitano Shrine in 1587.

In the resulting conflict of sensibilities Rikyū was also forced to commit suicide. Among the several unproved charges was that he had made money out of simplicity, that he had demanded exorbitant prices for his tea utensils. It was perhaps not the illegality of this that caused comment but its vulgarity—the extracting of common profit from an activity presumably free from just such ambitions.

ning poetry or painting pictures extolling the natural state. We are instead asked to pay attention to the natural elegance of this dispassionate regard of nature, and to admire the good taste of the milkmaid.

THE ELEGANCE OF simplicity—beauty to be found in the texture and grain of wood and stone, in visible architectural structure, also in the precise stroke of the inked brush, the perfect judo throw, the rightness of the placing of a single flower. This beauty is both the expression and the result of an awareness that comes from a highly self-conscious regard of nature, as well

Simplicity—this was something that Rikyū tried to teach his pupil, Hideyoshi, at whose "court" he was arbiter. One famous anecdote illustrates his method. Rikyū's garden of morning glories was known for its beauty. Hearing of it Hideyoshi demanded that he be invited to visit. So he was, but when he arrived all the morning glories were no more; they had all been scythed. Perturbed, Hideyoshi retired to the nearby tea house, and there the modest flower arrangement in the alcove was a single morning glory, the only survivor, superb in its focused simplicity. The warlord is supposed to have stared, then nodded, and said that he understood the lesson.

as from an accompanying discipline that is one of the reasons the arts are rarely casual in Japan.

But such a subjective term as "taste" (even under a rubric as generous as good-sense equals good-taste) needs to be codified. Though Japan is much more interested in (and better at) synthesis than analysis, some means of cataloguing was necessary to understand (and explain) the local aesthetic impulse. It is thus that Japanese good taste was early divided into a number of tastes.

Let us first consider one of them. This is that courtly taste for grace and refinement which we must call elegance. In Japan it is a perennial, and its graceful blossoms have been given several names. We will begin with *fūryū*.

Though one now sees the term *fūryū* mainly in advertising copy in fashion magazines, meaning something like "stylish," the term has a long and more serious aesthetic history. The original Chinese term, *fengliu,* meant "good manners," and when it reached Japan toward the beginning of the Heian period (794–1185) it retained this definition of social rectitude. To this was later added its aesthetic hue—refined manners as reflected in things regarded as tasteful or elegant.

At the same time, however, the term was seman-

Japanese aesthetic terms not only lie like strata, one on top of another, but combine with each other. *Wabi* and *sabi* mingle promiscuously and also have relations with *yūgen* at one extreme and with *fūryū* at the other. This intimacy of aesthetic attributes amounted to an ambition. The people in *The Tale of Genji* (ca. tenth century) are all concerned with refinement, with beauty, with elegance. There was a term for this hoped-for mingling—*miyabi*, which denoted the strongest appreciation for the finer things.

In this aesthetic welter let us attempt to define by translating the qualities of *fūryū* into terms appreciable to the contemporary Westerner, keeping in mind both the natural and minimal nature suggested, along with the simplicity, refinement,

tically evolving and acquiring different qualities. The Ashikaga shogun Yoshimasa, who ruled from 1449 to 1473, helped define some of these. His example gives an idea of the meanings of the word.

Yoshimasa had led a full and active political life and he was sick of it. The fifteenth century in Japan was just one civil war after another. Yet, if the shogun could not make peace he might still cultivate the peaceful qualities of the unostentatious, the subdued, the meditative, all of which shortly became elements of *fūryū,* qualities of refinement harking back to the elegant and now vanished Heian period.

The shogun had also learned that anything per-

and discernment implied.

Substitute as object of contemplation the basic black Chanel suit, full of *fūryū*; or native African pottery, refined over generations but made of common earth; or the music of Erik Satie, composed of common harmonies cunningly juxtaposed, the mostly unadorned melody sculpted with flair and style.

Japanese *fūryū* had something else as well. When objects exhibiting it were brought together they created a special kind of atmosphere, the essence of which is a sort of assured serenity. Listening to Satie while wearing a Chanel suit and looking at a Bantu pot only faintly suggests this quality. One will here simply have to imagine what it was like to exist beautifully in an environment composed of nothing but the most elegant simplicity.

fect arouses the acquisitive instinct. To avoid this, his buildings, his gardens, his vases and plates were made (with a wonderful natural grace it is true) of the plainest materials, the materials of nature itself, and this added a new layer of meaning to *fūryū*. He would have approved of the several haiku of Matsuo Bashō (1644–94) that find the beginnings of this quality in the natural, rural simplicity of rice-planting songs in the inelegant countryside.

THE OSTENTATIOUS RUSH for the unostentatious *fūryū* that developed following Yoshimasa's aristocratic example might be partially explained in that

Culture's beginning
Rice-planting songs from
The heart of the country

Singing, planting rice
Village songs more lovely
Than famous city poems

TWO BASHŌ HAIKU IN
ANONYMOUS TRANSLATIONS

the concept agrees so well both with a basic Buddhist doctrine that this man-made world is a delusion and with the equally strong "native" Japanese belief that the only way to live in this world is to subject oneself to its natural immutable laws.

This sensibility is no stranger to the West. The seventeenth-century English poet Edmund Waller compares his beloved to a rose and then, in fine Japanese fashion, tells the flower to be his messenger, to go and die before her eyes "that she the common fate of all things rare may read in thee."

Yoshimasa would have understood. The poem by no means issues an invitation to gather ye rosebuds while ye may. Rather, it acknowledges the transience of all things—and it attempts to find beauty and consolation in this acknowledgement.

Many people everywhere spend their whole lives trying to escape the thought that one day they and all of theirs will be no more. Only a few poets look at the fact, and only the Japanese, I believe, celebrate it.

This commemoration takes many forms but the most common might be looking into a mirror, seeing one more gray hair, discerning one more wrinkle, and then saying to oneself: "Good, all is well with the world—things are proceeding as they must."

This attitude (the opposite of going to the beauty

parlor) also gives pleasure—the pleasure of discovering a corroboration of this great and natural law of change in one's own personal face. This attitude extends to the outside world and seeks out a disassociated and satisfied melancholy. Cherry blossoms are to be preferred not when they are at their fullest but afterward, when the air is thick with their falling petals and with the unavoidable reminder that they too have had their day and must rightly perish.

Immortality, in that it is considered at all, is to be found through nature's way. The form is kept though the contents evaporate. Permanence through materials (granite, marble, the Pyramids, the Parthenon) is seldom attempted. Rather, the claims of immortality are honored in another way. Here the paradigm would be the Shinto shrine of Ise, made of common wood, razed every twenty years and at the same time identically rebuilt on a neighboring plot. *Yūgen, wabi, sabi,* as we shall see, all indicate a quality that finds permanence only in its frankly expiring examples.

THE URGE TO elegance enlarged the opportunities for expressing it. After the aesthetic formulations of the Ashikaga shogun, succeeding eras revived or coined many terms that could describe desired qual-

"Elegance—at least the elegance perfected by Bashō and others—in essence is the extreme intensification of sensibility. No matter how religious or philosophical it may be, it is thoroughly artistic. In literature the art of elegance chooses impromptu poetry, closest to silence; in art, monochrome painting, closest to emptyness."

SATŌ HARUO

from *Discourse on "Elegance"* (Fūryū no ron), translated by Francis Tenny

ities. One such was a Muromachi-period (1333–1568) term—*shibui.*

The adjectival form of the noun *shibusa* (or *shibumi*) originally described something astringent, dryish. Classical references to *shibushi* sometimes used the taste of an unripe persimmon to suggest the quality. It is still the antonym of *amai*, meaning "sweet."

The elegance that *shibui* suggested was perhaps due to an implied distinction—the sweet and the colorful were for the commoner sort of folk, those lacking the sophistication necessary for the elegant appreciation of the subtle and the unobtrusive, sour and bitter though this taste might seem. Shortly its use was no longer confined to color and design and good taste, but to social behavior in general.

Of its implications the aesthetician Yanagi Sōtetsu has written: "It is this beauty with its inner implications that is referred to as *shibui*. It is not a beauty displayed before the viewer by its creator . . . viewers must seek out the beauty for themselves. As our taste grows more refined we will necessarily arrive at the beauty that is *shibui*."

Though originally an aesthetic sensibility (and thus related to such terms as *wabi, sabi* and, much later, *iki*), *shibui* eventually came to describe a certain kind of demeanor as well—the use of subdued colors,

simple patterns, singers with unostentatious deliveries, actors who blended with the ensemble. Ueda Makoto mentions a baseball player said to be *shibui* when he makes no spectacular plays on the field but contributes to the team in an unobtrusive way.

Shibui baseball players indicate that the adjective is still used. It is a term one sometimes encounters in ordinary conversation, and everyone still knows more or less what it means. I was recently complimented on a necktie that was approvingly seen as *shibui*. It was a subdued tie, brownish, slightly murky, but with a nearly indiscernible touch of dark green threaded in it.

Another reason for the long life and popularity of *shibui* is that it rhymes so well with another equally used term for proper social taste. This is *jimi,* usually translated as simple "good taste," though it does have a pejorative edge. When a plainish kimono is worn in a group wearing brighter garments, a close friend might remark (with a smile): "Isn't that a little *jimi*?"

A part of the reason for the presence of *jimi* is that it has an antonym—something it may be defined against. This is *hade*—a term we would have to translate as "loud." In Japanese, however, the term is not pejorative—as it is in English. A common phrase is *hade de ii* or "nice and loud."

Over the years *shibui* has been to an extent sub-

sumed into the more popular *jimi*, and the two are now fruitfully confused. Nonetheless, *shibui* still retains the greater specific gravity. There is a darkness at its core (after all, it represents mainly negative virtues) that remains slightly esoteric and makes the term sometimes a synonym for something more mysterious than was perhaps originally intended.

Both *shibui* and *shibumi* have been commercialized in the United States and Europe. An early appearance was a two-page spread in *House Beautiful* (1960) that made the term something of a beauty aid. This duplicated internationally the domestic popularization of *shibui* that occurred in Japan itself during the Edo

Delighted, he took it back home and eventually showed it to a senior counsellor. This man, something of a connoisseur, insisted upon acquiring it. He too was delighted with his purchase and eventually showed it to his master, lord of the domain Hosokawa Tadaoki, who said he had to have it for his collection.

Obtained, it became famous in tea-ceremony circles and was passed down through the generations of the Hosokawa clan until, a century later, it was bought by the Matsudaira family for something between 350 and 500 *ryo*, an amount then equivalent to the income of a master craftsman over three or four years. It is still with us, known as being among the finest of all tea caddies and so pictured in the illustrated encyclopedias of famed tea utensils.

period (1600–1868), when the more wealthy townspeople of the capital began to pride themselves on their refined taste, and *shibui* entered common parlance.

LET US NOW look at *wabi* and *sabi,* the traditional Japanese aesthetic terminology most famous in the West, perhaps because the accidental alliteration of the words suggests a fruitful affinity. And the two are related, to be sure, both in their affinity and in their histories.

Sabi is an aesthetic term, rooted in a given concern. It is concerned with chronology, with time and its effects, with product. *Wabi* is a more philosophical

concept, a quality not attached merely to a given object. It is concerned with manner, with process, with direction.

Sabi, perhaps the earlier of the terms, derives from a number of sources: *sabu*, a verb meaning "to wane," and a noun, *susabi*, which can mean "desolation" and does so in the early poetry collection *Man'yoshu* (late eighth century). Other meanings include *sabiteru*, "to become rusty," by extension "to become old," and the adjective *sabishi* which meant, and still means, "lonely."

In its earlier appearances, in the works of the poet Fujiwara no Shunzei (Toshinari; 1114–1204) and those attributed to the poet-priest Saigyō (1118-90), *sabi* referred to scenes desolate and lonely, finding in them a lyric melancholy. Saigyō wrote (in Donald Keene's translation:

> *A mountain village*
> *Where there is not even hope*
> *Of a visitor.*
> *If not for the loneliness,*
> *How painful life here would be.*

Later theoreticians such as Zeami continued to discover in this bleak quality of desolation a special

kind of beauty. Later yet this quality was prized by Bashō, whose poetry has been described by Hisamatsu Sen'ichi as suggesting "tranquillity in a context of loneliness."

Bashō indeed did much to rehabilitate and modernize the concept of *sabi* and sometimes posited stillness as a basis for this quality, as in the famous haiku from the *Narrow Road of Oku* (1689), which Donald Keene has translated as:

> *How still it is*
> *Stinging into the stones,*
> *The locusts' trill.*

A Western parallel has been suggested by Robert Brower in the reflective melancholy of the romantic poets, Wordsworth's "sweet mood when pleasant thoughts / Bring sad thoughts to the mind," suggesting, like Saigyō, that loneliness is something to be savored.

A difference is that the English poet's emotions were occasioned (as the rest of the poem indicates) by a meditation on the relations of man with the universe. The Japanese poet's emotions were more intuitive than philosophical, and were directly occasioned by aspects of nature itself.

One etymological explanation of *sabi* translates it as "the bloom of time." This reading of *sabi*—cold and chill but beautiful—agreed well with a Buddhist-influenced ethos that recognized loneliness as a part of the human lot and therefore sought to become resigned to it and to find a kind of beauty in it. A twelfth-century poem by the priest Jakuren (1139–1202) begins: "Loneliness (*sabishisa*)—essential color of a beauty not to be defined."

Later medieval writers used the term as synonymous with the related term *hie,* which has been translated as designating a chill beauty (the word is still used—you ask for *hiezake* and you get cold saké). The Muromachi poet Shinkei spoke of *hiesabi.*

In modern times the various meanings of *sabi* have been largely maintained. One of these indicates the patina of "rust," of age. Theodore de Bary has recounted such a use overheard when the Kinkakuji (Gold Pavilion) was rebuilt after its destruction by fire in the 1950s. It was dazzling in its splendor but Professor de Bary overheard someone saying: "Let's wait ten years, till it's gotten some *sabi*."

WABI, LIKE SABI, recommends the appreciation of an austere beauty and a serene and accepting attitude toward the cold vicissitudes of life. It was derived from

the verb *wabu* (to fade, dwindle), and the adjective *wabishi* (forsaken, deserted) originally meant something just this unpleasant. By the Kamakura period (1185–1333), however, the meaning had turned more positive. A difference is that whereas *sabishi* (lonely) refers primarily to that emotional state, *wabishi* is used most often to describe the actual conditions under which one lives.

The great explicator of Zen Buddhist principles, Suzuki Daisetz, described *wabi* as "an active aesthetical appreciation of poverty," adding that it means "to be satisfied with a little hut, like the log cabin of Thoreau . . . with a dish of vegetables picked in the neighboring fields, and perhaps listening to the pattering of a gentle spring rainfall."

Poverty and loneliness could be seen as a liberation from strivings to become rich and popular. The root of *wabi* is *wa*, that syllable referring to harmony, tranquillity, peace. Beauty could be created from simplicity, and abundance could be found in poverty. These became the assumptions of those who later cultivated the ideal of the tea ceremony and sought to elevate their practice by associating it with such "Zen-like" attributes as artlessness.

One of their number, Takeno Jōō (1502–55), cited with satisfaction a poem by Fujiwara no Teika

(Sadaie; 1162–1241)—here in Ueda Makoto's translation—as containing the essence of *wabi*:

> *As I look afar I see neither cherry blossoms*
> *nor tinted leaves;*
> *Only a modest hut on the coast in the*
> *dusk of autumn nightfall.*

The poet, surveying the scene, chooses not the pink and festive cherry nor the bright red maple, two favorite if *hade* seasonal sights. Rather, he chooses deep autumn, conventionally the darkest of the seasons, and dusk, that time of day when all that is brilliant disappears into the monochrome of twilight.

The implication is that any accepted idea of elegance as something ornate, complicated, contrived, is wrong. True elegance is found, rather, in the opposites of these qualities. This was something that was notably cultivated by the tea ceremony, the *chanoyu*.

Murata Jukō (1422–1502) indicated this by performing the tea ritual for his aristocratic audience in a single, humble, four-and-one-half-mat room. His "reforms" were continued by Takeno Jōō and fully formulated by Sen no Rikyū. the most famous tea-master and master aesthetician of them all.

Rikyū's *chanoyu* was called *wabicha*. Through

it he taught that poverty had its own elegance, as reflected in the rustic tea house, in the superb simplicity of the common tea cup, and in the ordinary, if heightened and self-conscious, good manners of both tea-master and his guests.

Abundance is unnecessary or, worse, vulgar. The one may stand for the all—less is always more. These are among the lessons that Hideyoshi might have drawn. They are certainly among those offered by the later haiku poets including notably Bashō, for whom *wabi* was so much a poetic principle that it became a way of living—*wabizumai*, the "life of *wabi*."

This imposed simplicity, though perhaps a paradox, is at the same time one that would have been quite familiar to a courtier at Versailles. In actuality none of the Japanese aesthetes and tea-masters lived in "a modest hut on the coast." Like Rikyū they had luxurious homes in the compounds of wealthy warlords.

Indeed, one might venture that the aesthetic urge to be simple was based in part upon some kind of reaction to otherwise ornate and complicated lives. It might also be seen as akin to that affectation of simplicity to be noticed in the garb of our contemporary young—jeans torn and slit or otherwise "distressed," country-style "lumberjack" shirts and clod-hopper

Aesthetic terms indicate an attempt to define the otherwise indefinable. They are part of a net of words through which we would capture and control our feelings. But the task—the definition of feeling—is difficult. So, other means are sometimes attempted—those that indicate rather than state.

One of these is that colorful invention—the aesthete. We are mostly familiar with him (half figure of reverence, half figure of fun) through his nineteenth-century European examples. Art instead of life, or as an alternative to life—this was their creed. Art for its own sake.

Oscar Wilde was an early English example both in his attitudes and in his aphorisms. "The first duty in life is to be as artificial as possible. What the second duty is no one has yet discovered." In France, des Esseintes, hero of one of J.-K. Huysmans' novels, unsuccessfully sought an entirely artificial life, and Villiers de l'Isle-Adam has one of his characters say, "Live? Our servants will do that for us."

Japan had few figures as eccentric, but it did have *bunjin*, who, imitating the Chinese example of the scholarly amateur landscape artist freed from the constraints of style and school, created art of a remarkable individuality. These Japanese *bunjin* understood the literati tradition as

footware, the working-person's tanned skin—all on youngsters who never hopped a clod and whose complexion is the expensive work of the tanning salons.

This affectation of the proletariat (Veblen's famous phrase) might have political overtones for us, but for the fourteenth-century Japanese tea-master

a rejection of academic style and were thus free to create for its own sake a more personal kind of art. And to exhibit a more eccentric way of creating it. Many are the stories of odd behavior, alcoholic excess, excessive dalliance, and such experiments as placing live spiders in *ikebana* to render a more startling seasonal touch.

In both Japan and Europe the impetus behind aestheticism was much the same. In England things aesthetic were erected against the materialism and capitalism of the late Victorian period; in Japan, the reaction was against the restraints of the Edo era and later. Aestheticism was a revitalizing influence in times of oppression, complacency, and hypocrisy. It was a true search for beauty and it sought to give this beauty an independent value.

In Victorian England Max Beerbohm noted: "Beauty had existed long before 1880—it was Oscar Wilde who managed her debut." In Muromachi Japan beauty had been rediscovered through taste. And just as the European aesthetes revived archaistic modes and archaic language (Chaucer, Spencer), so the Japanese aesthetes revived Heian-period language and literature. Both created their separate golden ages the better to define and to castigate those in which they lived.

the emphasis was entirely aesthetic—based though it may have been upon the political wish to make the profession more respectable.

AMONG JAPANESE AESTHETIC terms, *aware* is a special case, an expression that became increasingly

important through its variations. Originally (Heian period), *aware* was akin to an interjection, like "ah, or "oh", expressing emotion but also controlled feeling. Murasaki Shikibu is said to have referred to it over a thousand times in *The Tale of Genji*. Eventually it came to stand for anything between elegance and pathos.

Aware (the verb form of which means "to commiserate" or "to pity") is perhaps closest to *sabi*. In both, the wistful melancholy of the sympathetic response is stressed. But as Brower has phrased it, "the consciousness of isolation and the astringent qualities of the imagery of *sabi* make it significantly different as well as more limited than the concept of *aware*."

Aware is applied to the aspects of nature (or life, or art) that move a susceptible individual to an awareness of the ephemeral beauty of a world in which change is the only constant. His or her reaction may be a resigned melancholy or an awe, or even a measured and accepting pleasure. There have been various valiant attempts to translate the term *aware* into English, a language that has no way of doing so.

The more modern variant of *mono no aware* is ascribed to the scholar Motoori Norinaga (1730–1801), who revived (some say invented) the term as a way to prove native Japanese thought (as opposed

There are other aesthetic terms. Apparently so great was the need that these definitions positively proliferated. A partial list would include:

ate—a Heian-period term meaning refinement, gentility based on exalted status.

en—another Heian word, meaning a rich, at once apparent, buoyant beauty.

fūga—elegance (*yūbi*), sublimity (*yūdai*).

hosomi—emotional delicacy, a determination to slight not even the most trivial, to understand the beauty of just anything—a haiku term.

karumi—the beauty of simplicity, the unadorned expression of a profound truth—another haiku term.

kurai—dignity, even loftiness, quietly or even coldly beautiful.

mumon—literally, without pattern or design; accomplished in a straightforward and unhesitant manner.

okashi—a Heian term that originally meant appealing or charming. Later it came to mean amusing or witty; it survives in modern Japanese as something "funny" or absurd.

reiyō—suggesting a smooth and graceful beauty.

taketakeshi—a very old term meaning a union of strength and nobility, an aesthetic ideal of such medieval poets as Shunzei and Teika.

yasashi—originally, pleasingly shy; later, indicating a soft (and feminine) beauty. The term survives in modern Japanese and still means the same things.

yū—another term for "graceful" or "refined"; often seen as something like "elegant."

to imported Chinese influence) superior and, in fact, "unique."

Mono no aware was in its modern sense

extended to define the essential in Japanese culture. Its aim became political. At the same time, however, something definitely there is being described.

WE CAN ALL experience *aware.* All of us do not seek to define it. But Japan does, and from *aware* (in all of its senses) sprouts such related aesthetic categories as *wabi* and *sabi* as well as, among many others, *yūgen.*

Yūgen as a concept refers to "mystery and depth." *Yū* means "dimness, shadow-filled," and *gen* means "darkness." It comes from a Chinese term, *you xuan,* which meant something too deep either to comprehend or even to see. In Japan the concept became (in Brower's words) "the ideal of an artistic effect both mysterious and ineffable, of a subtle, complex tone achieved by emphasizing the unspoken connotations of words and the implications of a poetic situation." The indeterminacy of the meaning can be ascribed, as does William LaFleur, to Tendai Buddhist tenets concerning the interdependency of all things. The result, as constructed by Howard Rheingold, is "an awareness of the universe that triggers feelings too deep and mysterious for words."

It is also the term for a style of poetry, one of the ten orthodox styles suggested by Fujiwara no Teika; it was also early linked with *sabi* by Fujiwara no

Ivan Morris reads *aware* as "pathetic, moving," and *mono no aware* as corresponding to Virgil's *lacrimae rerum*, "the pity of things."

As phrased by Earl Miner, "*[aware]* suggests an anguish that takes on beauty, or a sensitivity to the finest—the saddest—beauties. Both the condition and the appreciative sensibility are implied."

Tsunoda, Keene, and de Bary find that *aware* "expresses a gentle sorrow, adding not so much a meaning as a color or a perfume to a sentence."

Ueda Makoto's paraphrase runs: "A deep, empathetic appreciation of the ephemeral beauty manifest in nature and human life, and therefore usually tinged with a hint of sadness [though] under certain circumstances it can be accompanied by admiration, awe, or even joy."

Michael F. Marra has described *mono no aware* as "a person's ability to realize the moving power of external reality and, as a result, to understand and, thus, communicate with others."

More modern attempts have included "*c'est la vie*" and "that's the way the cookie crumbles."

Shunzei) to describe beauty accompanied by sadness. The interpretation was approved by Kamo-no-Chō-mei (1155–1216), author of *Hōjōki* (An Account of My Hut), who wrote in the *Mumyōsho* (Treatise without a Name, Brower and Miner translation) that for him *yūgen* was to be found "on an autumn evening when there is no color in the sky nor any sound, yet although we cannot give any definite reason for it, we are somehow moved to tears."

The average person would find nothing moving about such a scene. He could admire only the cherry blossoms and maple leaves. This is because he lacked the sensibility to discern the beautiful pathos that *yūgen* expresses. This can occur only (Brower and Miner translation) "when many meanings are compressed into a single word, when the depths of feeling are exhausted yet not expressed, when an unseen world hovers in the atmosphere . . . when the mean and common are used to express the elegant, when a poetic conception of rare beauty is developed to the fullest extent in a style of surface simplicity."

As a quality *yūgen* is now mostly associated with the No drama, with a veiled nature seen through an atmosphere of rich if mysterious beauty. Here the *yūgen* of No is defined by the dramatist, actor, and aesthetician Zeami Motokiyo (1363–1443) as com-

bining the *yūgen* of speech, the *yūgen* of dance, and the *yūgen* of song. The actor must (in the Rimer and Yamasaki translation) "grasp these various types of *yūgen* and absorb them within himself." No matter the character (lord, peasant, angel, demon), "it should seem as though each were holding a branch of flowers in his hand. He should offer this fresh, mysterious reality."

Arthur Waley has commented upon Zeami's use of the term and given a kind of definition: "[*Yūgen*] means 'what lies beneath the surface'; the subtle, as opposed to the obvious; the hint, as opposed to the statement. It is applied to the natural grace of a boy's movements, to the gentle restraint of a nobleman's speech and bearing. . . . 'To watch the sun sink behind a flower-clad hill, to wander on and on in a huge forest with no thought of return, to stand upon the shore and gaze after a boat that goes hidden by far-off islands' . . . such are the gates of *yūgen*."

HERE WE MIGHT notice our own attempt at this categorization of aesthetic concepts. In the West one cannot too successfully accomplish this—though Plato, Addison, Hegel, Hume, Kant, and many others tried to. In Japan, however, there is apparently no problem. Aesthetic categories thrive.

All of which does not imply that Japanese aesthetics do not have a political dimension as well, as their advocate Motoori Norinaga perfectly understood. They still serve to separate status and class. The "fine arts" of Japan (No drama, the art of calligraphy, *ikebana*, etc.) are the preoccupations of the socially powerful, the wealthy. In addition, aesthetic concepts and definitions have evolved to favor more political definitions.

David Bordwell has indicated this when he writes, "The artistic concepts purportedly shaping all Japanese art (*wabi, yūgen, iki, mono no aware*) often turn out to have complex and ambivalent histories, during which they were redefined for various purposes. More generally, a great many 'distinctively Japanese' traditions, from emperor worship to the rules of *sumo* were devised in the nineteenth and twentieth centuries by elite factions forging new national identities for a modernizing society. . . . Someone may respond that whereas we [of the West] have lost touch with premodern customs and ways of thinking, the Japanese have retained a living relation to theirs. Yet this idea itself is no less an invented tradition, with sources in twentieth-century Japanese enthnology and cultural theory."

As do categories within categories. One of these might here be mentioned both because it is sometimes overlooked and because it gives some insight into the Japanese aesthetic sense at work. It describes what we can call the "mood" of whatever it is in which we are engaged: flower arrangement, tea ceremony,

calligraphy, garden design, dyeing kimono fabric, deportment. It involves an agreed-upon tripartite system of categorization that early aestheticians hoped would account for all attributes of these activities and their reflections.

The three-part formula is referred to as *shin-gyō-sō*. The first term, *shin*, indicates things formal, slow, symmetrical, imposing. The third is *sō* and is applied to things informal, fast, asymmetrical, relaxed. The second is *gyō* and it describes everything in between the extremes of the other two.

The application differs according to both the subject and the aesthete using the system. A *shin* garden for, example, is usually both public and grand, belonging to a temple or a fine residence. A garden deemed *gyō* is both formal in some aspects and informal in others, as in a stylish private residence. The *sō* garden is decidedly informal and is often found in rural areas around peasant homes.

In *ikebana* a *shin* flower arrangement is formal, narrow in shape, and ceremonial in position—in the tearoom's *tokonoma* alcove, for example. The *gyō* arrangement has a wider profile and some movement is implied—the use of autumnal leaves for seasonal effect, say. The *sō* flower arrangement is decidedly informal in both its shape and the

space it occupies—sometimes ending up in a vase on the wall.

In a *tokonoma* arrangement that uses an art work along with the flowers or with a *bonsai* miniature tree, the scroll in the precise center of the space indicates *shin*, slightly off center designates *gyō*, and more off center yet, in fact decidedly asymmetrical, specifies *sō*.

Flower-master Teshighara Sōfū once said that *shin* is a traditional *tokonoma* alcove floored with tatami mats, its main post lacquered and all of its proportions exact and formal, but that *gyō* is a *tokonoma* floored with wood, its grain still showing and its post perhaps a natural tree trunk. He said he had never heard of a *tokonoma* in the *sō* manner, as they are simply not made that way, but surely the rudimentary *tokonoma* of some rustic tea-ceremony hut somewhere might theoretically approach *sō* in its informality.

An alternate reading defines *shin* as shaped by man, *sō* as the natural state, and *gyō* as both *shin* and *sō* complementing each other. This is the interpretation adapted in the earliest foreign account of the system, Josiah Condor's *Landscape Gardening in Japan* (1893), where he called *shin* "finished," *gyō* "intermediary," and *sō* "rough."

Further alternates are also possible. *Kyūdō* (the

art of archery) identifies *shin* as "following the truth," that is, the fundamentals followed, the technique; *gyō* is the carrying out of these in the actual shot, a demonstration of this principle; *sō* is the natural form that insures the shot is in harmony with the place, the time, the person.

One of the more recondite uses of this tripartite system is found in the martial arts and governs bowing. The *shin* bow performed while sitting involves touching the back of one's outstretched hands with one's forehead. The *shin* bow while standing requires a movement of at least forty-five degrees. This is reserved for superiors and elders. For inferiors and subordinates, the *sō* bow is adequate. This involves head and back tipped only slightly. The *gyō* bow would be some combination of the other two.

This is not the end of the complications, however. The three divisions, *shin*, *gyō*, and *sō*, are each divided into another three. The *shin-no-shin* would be the most formal "formal" bow. A *gyō-no-shin* would be a semi-formal "formal," and the *sō-no-shin* would be an informal "formal."

The origin of this aesthetic system is thought to be the three styles of calligraphy categorized in China and early introduced into Japan. There was the formal block-style of writing the *kanji* character, the much

looser style to be used in writing *kana* characters, and the very loose abbreviations of cursive script.

Shodō (the Japanese art of calligraphy) identifies as *shin* (*kaisho*) the original Chinese non-cursive character. This is broken down into the *gyōsho* (semi-cursive) and *sōsho* (cursive) forms.

Stephen Ogden, in writing of these early calligraphic beginnings, translates the *shin* as "true," the *gyō* as "moving," and the cursive *sō* as "grass-like." He refers to the system itself as "a schema for mapping the uniquely Japanese manner of reacting to any discrete new foreign encounter."

All of this might be thought not only archaic but also requiring of some special knowledge in order to be understood. Actually, this is not so. Let us move the system to some place closer to home and see how it works.

The Washington Monument is *shin*. It is symmetrical, formal, correct, official, imposing, and at the same time almost elaborately beautiful. *Sō* is the contrary, and though we have no public monuments in this style (all of them being *shin* by definition of being monuments), a Frank Lloyd Wright house might serve as an indication. It is asymmetrical, informal, relaxed, and is at the same time both simple and beautiful.

This tripartite system of categorization can also explain mood in terms of strength and warmth. Thus cats are *shin* but dogs are *sō*. In the same way Sean Penn is very *shin* though Brad Pitt is quite *sō*. Or Mozart is a very engaging aspect of *sō* tempered with *shin*, while in Beethoven we have s*hin* tempered with *sō*, and Brahms is all *gyō*. There are numerous other applications.

The *shin-gyō-sō* formula is also useful in indicating historical and geographical positions. Commonly, as we have seen, *shin* are those objects shaped by man; *sō*, those left to nature; and *gyō*, those blending the two. Or, historically, *shin* is the original form, usually that which has been imported into Japan (mainly from China and Korea); *sō* is the form after it has been subjected to a stay in Japan, where it is thought to have been ameliorated, grown pliant, the formal made informal or "natural," thus validating its absorption.

The tea ceremony, for example, designates as *shin* those matched utensils of bronze or other worked materials—usually Chinese in origin or inspiration. In contrast Japanese utensils (often clay, wood, bamboo) are *sō* while *gyō* are those Japan-made but modeled after Chinese originals.

There are also, as has been indicated, a number of combinations that are applied to varying inter-

Formulas for categorization and explanation are common in traditional Asian aesthetics. In Japan there are several, most of them (like the *shin-gyō-sō* template) of Chinese origin. Two of the most frequently met with are *ten-chi-jin* and *jō-ha-kyū*.

The former is encountered in many of the traditional arts. Here the *ten* refers to the sky or heaven, the *chi* to the ground or earth, and the *jin* to the human, whose duty it is to coordinate the other two. In *ikebana* the various lines of the flower arrangement are sometimes thus named. In the military arts this identification is also used.

The latter formula is even more widespread among the arts. *Jo-ha-kyū* is a concept directly imported from China and was first used in reference to Gagaku, the early court music of Japan. A common translation of this tripartite pattern is introduction, development, finale.

mediary degrees of the three moods. Hemingway would probably be the *sō* of *gyō*, while Faulkner would perhaps be the *sō* of *shin*. There are nine such combinations in all—like the nine postures of the Amida Buddha—and the collective Japanese word for this process is *santai kyūshi* (three bodies, nine forms).

All of this aesthetic terminology might seem pettifogging to the Westerner, though a quick look into the more recondite pages of Emily Post or even Martha Stewart will remind us of like constructions. Actually, formulations such as the *shin-gyō-sō* trip-

But such a rendering does not begin to suggest the richness of the associations. The introduction *jo* is (in music and in drama) to be of a slow but free rhythm; the exposition *ha* is to be in the establishing rhythm: the *kyū* is the rhythmic climax, relatively fast, followed by a final return to the *jo* tempo. This is sometimes rendered into English as larghetto, con brio, allegro, and a final diminuendo. Zeami likened the concept to a narrow stream that becomes a wide river, and ends with a waterfall hurtling into a still pool.

Many uses are found for this template. It can govern almost anything of any duration, including the progress of those poetic competitions called *renga*. Zeami, again, elaborated its effects—it was to be detected not only in the shape of music or the dramatic presentation but also in every instrumental or vocal phrase, in every step, in every word.

tych serve the same purpose of some in the West—shorthand in the discussion of a complicated art.

THE JAPANESE OF the fifteenth century—like those of the twenty-first and all the centuries in between—delighted in such rules and categorizations When people gathered and talked about an artistic work the atmosphere perhaps resembled some New York or Paris opening with recently acquired apparel being shown off and much connoisseur-talk about the merits of this or that—whether the pot or the bowl or the *ikebana* showed the *shin* of *shin* or merely

the *gyō* of *shin*. Still, the emotion called for, the real reason for the party, is familiar. It is the pursuit of beauty.

On such occasions, a standard of taste is agreed upon. Good taste is thus a shared discovery that fast shades into a conviction. It may have its origin in the unpeopled world of nature itself but it soon enters proper society. In Japan, particularly from the seventeenth century on, Yoshimasa's courtly doings eventually became those of moneyed folk at large.

A favorite formulation was the dichotomy perceived between *ga* and *zoku*. Neither had anything to do with the laboring poor and both reflected social concerns. As explained by the *bunjin* poet-painter Gion Nakai (1676–1791), "*ga* is neatness, propriety, elegance; *zoku* is vulgarity." He left no examples but there are many samples left over from another aesthetic formulation—that covered by the term *iki*.

As Ueda Makoto has observed, not only was *iki* an aesthetic term, it represented a moral ideal. "Aesthetically it points toward an urbane, chic, bourgeois type of beauty with undertones of sensuality. Morally it envisions the tasteful life of a person who was wealthy but not attached to money, who enjoyed sensual pleasure but was never carried away by carnal desires. . . . "

Kuki Shūzō, who wrote a whole book on the subject, said that "the intoxication of the so-called *amour-passion* of Stendhal is truly contrary to *iki.*" Closer was Verlaine, who did not wish for color, "only for its shades." At the same time Kuki wondered if the pictures of Constantin Guys, Degas, and von Dongen, all painters of a contemporary aesthetic in the Paris he knew, were really "endowed with nuances of *iki.*" The negative is implied, but this is less important than that he thought to ask the question.

All of this has now had its day. *Iki* turns into "cool," Nature is put on the back burner, and method becomes media. Hence, the value of looking back along the long corridors of history and glimpsing a world where beauty was sought, where its qualities could be classified, and where a word for "aesthetics" was not necessary.

THE ARTISTIC IMPULSE in Japan was internalized to a degree uncommon in any culture. This being so, aesthetic concerns were so taken for granted that they could be employed with an unmatched ease and naturalness. This is illustrated in two artworks (*the* two artworks) from the Heian period, *The Tale of Genji* and the later anonymous scroll illustrating it. Time in the novel, writes scholar Katō Shūichi, is expressed by

Why should this be so, this anomaly of
Japan? One scholar who has given much
thought to the subject is Katō Shūichi.
His thesis is that during the long years of
its seclusion Japan became so internal-
ized that the artistic impulse, aesthetics,
quite took the place accorded religion in
other countries. "Japanese culture be-
came structured with its aesthetic values
at the center. Aesthetic concerns often
prevailed even over religious beliefs and
duties." In the later Buddhist sculpture
of the Heian period, writes Katō, "the
art was not illustrating a religion, but a
religion becoming an art." Later, under
the influence of Zen, there was "a process
of gradual dissolution of this originally
mystic discipline into poetry, theater,
painting, the aesthetics of tea, . . . in one
word, into art." And, still later: "The art of
Muromachi Japan was not influenced by
Zen." Rather, "Zen became the art."

the same function as space in the picture scroll. "The time portrayed in the literary work is the time of the everyday world—concrete, actual, unconcerned with ultimates. This lack of interest in eternity enables the novel to be so sensitive to the passage of time. The space of the picture scroll is the sensuous, subtle space of the everyday world, devoid of any rationally imposed symmetry. It is precisely its lack of interest in geometry that gives the picture scroll its infinite sensitivity toward the structure of space."

The only nation to become pragmatic concerning art (and thus happily disregarding those "ideal" aspects common to almost all other aesthetics), Japan presented during its integrated periods the still surprising spectacle of a people who in the most natural way made art a way of life.

In the Edo period, aestheticization reached extraordinary heights It was now that *bushidō*, the way of the warrior, was first rationalized and codified. Specific mention of *bushidō* as a readiness to die a beautifully noble death (an aesthetic decision) first came at a time when there was no longer a military need for any samurai to die by the sword. Necessary to a full and fixed aesthetic was, it seems, enforced seclusion, mandatory peace, and a society near stagnation.

Stagnation, however, is no longer an option—

not in our volatile times. The arts that such a concept of aesthetics supported are now largely fossilized, and those that remain are now commonly vulgarized. Any manual of Japanese aesthetics is to this extent now a closed book.

A basic assumption, however, remains. Aesthetic taste, like Miyamoto Musashi's five rings, indicates a method and still something of a hope. Though it does not seem likely, Jean de la Bruyère's dictum yet holds. To enjoy good taste we only have to decide for ourselves what good sense is.

GLOSSARY

ate あて a Heian-period term meaning refinement, gentility based on exalted status

aware 哀れ the aspects of nature (or life, or art) that move a susceptible individual to an awareness of the ephemeral beauty of a world in which change is the only constant

bigaku 美学 a coined modern Japanese term, equivalent to "aesthetics"

en 艶 a Heian word, meaning a rich, at once apparent, buoyant beauty

fūga 風雅 elegance (*yūbi*), sublimity (*yūdai*)

fūryū 風流 refined manners as reflected in things regarded as tasteful or elegant

ga 雅 neatness, propriety, elegance (as defined by Gion Nakai)

hade 派で loud and showy, but not necessarily garish

haiku 俳句 a short poem offering a concentrated observation of time and nature

hie 冷え chill beauty, somewhat like *sabi*

hosomi ほそみ emotional delicacy, a determination to slight not even the most trivial, to understand the beauty of just anything—a haiku term

iki　いき　an urbane, chic, bourgeois type of beauty with undertones of sensuality (as defined by Ueda Makoto)

jimi　地味　good taste in an understated, plain style

jo-ha-kyū　序破急　a tripartite pattern of introduction, development, finale

karei　華麗　gorgeous splendor (as defined by Michael Dunn)

karumi　かるみ　the beauty of simplicity, the unadorned expression of a profound truth; a haiku term

kodai　古代　antiquity

kurai　位　dignity, even loftiness, quietly or even coldly beautiful

miyabi　雅　Heian-period term suggesting the strong appreciation for beauty, refinement, and elegance

mono no aware　物の哀れ　a slightly sweet and sad quality as appreciated by an observer sensitive to the ephemeral nature of existence; "the pity of things" (as defined by Ivan Morris)

mujō　無常　a Buddhist concept suggesting impermanence

mumon　無紋　literally, without pattern or design; accomplished in a straightforward and unhesitant manner.

okashi　おかし　a Heian term that originally meant appealing or charming; now "funny" or absurd

reiyō　麗容　suggesting a smooth and graceful beauty.

sabi　寂び　a slightly bleak quality suggesting age, deterioration, and the passage of time

shibui　渋い　astringent, dry, subdued

shin-gyō-sō　真行草　a tripartite pattern of formal, mixed, and informal styles

soboku　素朴　artless simplicity (as defined by Michael Dunn)

taketakeshi たけたけし　a very old term meaning a union of strength and nobility, an aesthetic ideal of such medieval poets as Shunzei and Teika

ten-chi-jin 天地人　tripartite pattern of "heaven," "earth," and "human" as an embodiment of different styles, especially in flower arranging

wabi 詫び　a cultivated aesthetic that finds beauty in simplicity and an impoverished rusticity

yasashi 優し　originally, pleasingly shy; later, indicating a soft (and feminine) beauty

yū 幽　another term for "graceful" or "refined"; often seen as something like "elegant"

yūgen 幽玄　rich and mysterious beauty, now largely associated with No drama

zoku 俗　vulgarity (as defined by Gion Nakai)

zuihitsu 随筆　an essay that ranges somewhat formlessly; *hitsu* means "brush," and *zui* indicates "following" or "pursuing," thus, literally, "following the brush"

BIBLIOGRAPHY

Addiss, Stephen; Gerald Grosmer; and J. Thomas Rimer. *Traditional Japanese Arts and Culture*. Honolulu: University of Hawai'i Press, 2006.

Bordwell, David. *Figures Traced in Light*. Berkeley: University of California Press, 2005.

Brower, Robert H., and Earl Miner. *Japanese Court Poetry*. Palo Alto: Stanford University Press, 1961.

Chan, Peter. *Bonsai Master Class*. New York: Sterling Press, 1988.

Crowley, James and Sandra. *Wabi Sabi Style*. Layton, Utah: Gibbs Smith, 2001.

Cudden, J. A. *A Dictionary of Literary Terms*. London: Andre Deutsch, 1977.

de Bary, William Theodore. "The Vocabulary of Japanese Aesthetics." In *Sources of Japanese Tradition*. Compiled by William Theodore de Bary, Donald Keene, George Tanabe, and Paul Varley. New York: Columbia University Press, 2001.

Deutsch, Eliot. *Studies in Comparative Aesthetics*. Honolulu: University of Hawai'i Press, 1975.

Dickie, George; Richard Sclafani; and Ronald Roblin. *Aesthetics: A Critical Anthology*. New York: St. Martin's Press, 1989.

Dunn, Michael. *Traditional Japanese Design: Five Tastes*. New York: Japan Society/Harry Abrams, 2001.

_____. *Inspired Design: Japan's Traditional Arts*. Milan: Five Continents Editions, 2005.

Durston, Diane. *Wabi-Sabi: The Art of Everyday Life*. New York: Storey Publishing, 2006.

Fowler, Roger. *A Dictionary of Modern Critical Terms*. London: Routledge and Kegan Paul, 1987.

Freeland, Cynthia. *Art Theory: A Very Short Introduction*. New York: Oxford University Press, 2002.

Gold, Taro. *Living Wabi-Sabi: The True Beauty of Your Life*. Kansas City, Mo.: Andrews McMeel Publishing, 2004.

Haga Koshiro. "The *Wabi* Aesthetic through the Ages." In *Japanese Aesthetics and Culture: A Reader*. Edited by Nancy G. Hume. Albany: State University of New York Press, 1995.

Hirota, Dennis. *Wind in the Pines*. Fremont, Calif.: Asian Humanities Press, 1995.

Hisamatsu Sen'ichi. *The Vocabulary of Japanese Literary Aesthetics*. Tokyo: Centre for East Asian Cultural Studies, 1963.

Hume, Nancy G., ed. *Japanese Aesthetics and Culture: A Reader*. Albany: State University of New York Press, 1995.

Itoh Teiji, Tanaka Ikko, and Sesoko Tsune. *Wabi, Sabi, Suki: The Essence of Japanese Beauty*. Tokyo: Mazda Motor Corporation, 1992.

Izutsu, Toshihiko and Toyo. *The Theory of Beauty in the Classical Aesthetics of Japan*. Boston: Martinus Nijhoff, 1981.

Juniper, Andrew. *Wabi-Sabi: The Japanese Art of Impermanence.* Tokyo: Tuttle, 2003.

Katō Shūichi. *Form, Style, Tradition: Reflections on Japanese Art and Society.* Tokyo: Kodansha International, 1971.

Keene, Donald. "Japanese Aesthetics." In *Landscapes and Portraits: Appreciations of Japanese Culture.* Tokyo: Kodansha International, 1971.

_____. *World Within Walls.* London: Secker and Warburg, 1976.

_____. *Seeds in the Heart.* New York: Henry Holt, 1993.

_____, comp. and ed. *Anthology of Japanese Literature.* Rutland, Vt.: Tuttle, 1956.

Koren, Leonard. *Wabi-Sabi: for Artists, Poets, Designers, and Philosophers.* Berkeley: Stone Bridge Press, 1994.

Lafleur, William. *The Karma of Words: Buddhism and the Literary Arts in Medieval Japan.* Berkeley: University of California Press, 1983.

Lawrence, Robyn Griggs. *The Wabi-Sabi House: The Japanese Art of Imperfect Beauty.* New York: Clarkson-Potter, 2004.

Marra, Michael. "Japanese Aesthetics: The Construction of Meaning." *Philosophy East and West,* vol. 45, no. 3 (July 1995).

_____. *Modern Japanese Aesthetics: A Reader.* Honolulu: University of Hawai'i Press, 1999.

_____. *Japanese Hermeneutics: Current Debates on Aesthetics and Interpretation.* Honolulu: University of Hawai'i Press, 2002.

_____. *Kuki Shūzō: A Philosopher's Poetry and Poetics.* Honolulu: University of Hawai'i Press, 2004.

_____. *The Poetics Of Motoori Norinaga: A Hermeneutical Journey.* Honolulu: University of Hawai'i Press, 2007.

_____, ed. *A History of Modern Japanese Aesthetics.* Honolulu: University of Hawai'i Press, 2001.

Miller, Mara. "Teaching Japanese Aesthetics." http://www. aesthetics-online.org/ideas/miller.Htm.

Miner, Earl. *An Introduction to Japanese Court Poetry.* Palo Alto: Stanford University Press, 1968.

_____, Hiroko Odagiri, and Robert E. Morrell. *The Princeton Companion to Classical Japanese Literature.* Princeton: Princeton University Press, 1985.

Nabokov, Vladimir. *Lectures on Literature.* New York: Harcourt, 1980.

Nakano Mitsutoshi. "The Role of Traditional Aesthetics." In *Eighteenth-century Japan: Culture and Society.* Edited by C. Andrew Gerstile. Sydney: Allen and Unwin, 1989.

Nara, Hiroshi. *The Structure of Detachment: The Aesthetic Vision of Kuki Shūzō: With a Translation of Iki no Kōzō.* Honolulu: University of Hawai'i Press, 2004.

Odin, Steve. *Artistic Detachment in Japan and the West.* Honolulu: University of Hawai'i Press, 2001.

Okakura Kakuzo. *The Book of Tea.* New York: G. P. Putnam's Sons, 1906.

Pilgrim, Richard B. "Ma: A Cultural Paradigm." *Chanoyu Quarterly* (Kyoto), no. 46 (1986).

Powell, Richard R. *Wabi-Sabi Simple.* Avon, Mass.: Adams Media, 2005.

_____. *Wabi-Sabi for Writers.* Avon, Mass.: Adams Media, 2006.

Railey, Jennifer. "Dependent Origination and the Dual-Nature of the Japanese Aesthetic." *Asian Philosophy,* vol. 7, no. 2 (July 1997).

Rheingold, Howard. *They Have a Word for It*. New York: St. Martin's Press, 1981.

Richie, Donald. Introductory essay to *The Master's Book of Ikebana*. Tokyo: Weatherhill/Bijitsu Shuppan, 1966.

_____. Introductory essay to *Five Tastes: Traditional Japanese Design*. New York: Abrams/Japan Society, 2001.

Rimer, J. Thomas, and Yamazaki Masakazu. *On the Art of the Noh Theatre: The Major Treatises of Zeami*. Princeton: Princeton University Press, 1894.

Saitō Yuriko. "The Japanese Aesthetics of Imperfection and Insufficiency." *The Journal of Aesthetics and Art Criticism*, vol. 55, no. 4 (Autumn 1997).

Satō Haruo. *Discourse on "Elegance"* (Fūryū no Ron, 1924). Partial translation by Francis B. Tenny. In *The Columbia Anthology of Modern Japanese Literature*. Edited by J. Thomas Rimer and Van C. Gessell. New York: Columbia University Press, 2005.

Shirane Haruo. *Traces of Dreams: Landscape, Cultural Meaning, and the Poetry of Basho*. Palo Alto: Stanford University Press, 1998.

Spence, Jonathan. "The Explorer Who Never Left Home: Arthur Waley." *Renditions*, no. 5 (Autumn 1975).

Suzuki Daisetz. *Zen and Japanese Culture*. Princeton: Princeton University Press, 1959.

Tanizaki Jun'ichirō. *In Praise of Shadows* (In'ei Raisan). Translated by Thomas J. Harper and Edward G. Seidensticker. New Haven: Leete's Island Books, 1977.

Ueda Makoto. *Literary and Art Theories in Japan*. Ann Arbor: University of Michigan Press, 1967, 1991.

_____. Entries on aesthetics, *aware, fūryū, iki, ma, mono*

no aware, okashi, sabi, shibui, wabi, yojō, and *yūgen* in *Kodansha Encyclopedia of Japan.* Tokyo: Kodansha, 1983.

Veblen, Thorstein. "Conspicuous Consumption." Extract from *The Theory of the Leisure Class* (1899). London: Penguin Books, 2005.

Waley, Arthur. *More Translations from the Chinese.* London: George Allen and Unwin, 1919.

Yanagi Sōetsu. *The Unknown Craftsman.* Tokyo: Kodansha International, 1972.

OTHER BOOKS BY DONALD RICHIE

The Donald Richie Reader: 50 Years of Writing on Japan
edited and with an Introduction by Arturo Silva

The Inland Sea

*A Lateral View: Essays on Culture and Style
in Contemporary Japan*

*Viewed Sideways: Writings on Culture and Style in
Contemporary Japan*

Available at booksellers worldwide and online

9 781933 330235